City of Angels

Friendly yet elusive, up-to-date yet quaint, Bangkok is a city of confounding contradictions. Its relentless 21st-century modernity, manifested in traffic snarls and industrial-strength pollution, manages to coexist with Buddhist temples and flower-festooned spirit houses that serve as quiet reminders of spiritual tranquility. High-decibel motorized water taxis share the Chao Phraya with ornate, intricately carved royal barges. Thais blend music with their boxing and turn kite-flying into a battle. The government indulges the anything-goes carnality of the Patpong red-light district – and yet bans the movie *The King and I.*

For these reasons and many more, Bangkok has consistently piqued, charmed, and mystified visitors. Indeed, as the capital of a country never colonized by a European power (the name "Thailand," in fact, translates to "Land of the Free"), it has held a special mystique for Westerners. Among the European sojourners who have tried to capture the city's allure was novelist Joseph Conrad. "Here and there in the distance," he wrote in the 1880s, "above the crowded mob of low, brown roof ridges, tower great piles of masonry, giant palaces, temples, gorgeous and dilapidated, crumbling under the vertical sunlight, tremendous, overpowering, almost palpable." More puckishly, American humorist S. J. Perelman noted in the middle of the 20th century that Bangkok "seems to combine the Hannibal, Missouri, of Mark Twain's boyhood with Beverly Hills, the Low Countries and Chinatown." And latter-day travel writer Pico Iyer has called the Thai metropolis "every Westerner's synthetic, five-star version of what the Orient should be: all the exoticism of the East served up amidst all the conveniences of the West."

It's rather fitting that so many outsiders have struggled to divine and define Bangkok's true nature. After all, foreigners don't even call the city by its real name. Thais refer to their capital – home to roughly 15 percent of the country's population – as *Krung Thep* ("City of Angels"), a shortened version of its true, 175-letter name, which translates to "Great city of angels, the repository of divine gems, the great land unconquerable, the grand and prominent realm, the royal and delightful capital city full of nine noble gems, the highest royal dwelling and grand palace, the divine shelter and living place of reincarnated spirits." (Outlanders, meanwhile, derived the name "Bangkok" in the 18th century from that of a tiny local district, Bang Kok, meaning "place of olives.")

1. A weatherbeaten barge floats down the Chao Phraya, passing the Grand Palace.

Yet another contradiction inhabits the city's history: it's the capital of a civilization that is almost eight centuries old – but the metropolis itself is younger than the United States. The first capital, Sukhothai (in what is now central Thailand), was relocated to Ayutthaya in the 14th century. In 1766, the rival Burmese attacked Ayutthaya, laying siege to it for 15 months and eventually leaving it in ruins. So Thai general Taksin moved south again, to a site on the west bank of the Chao Phraya river, and established a new capital in the bustling mercantile village of Thon Buri. In 1782, still concerned about threats from Burma, Taksin's successor King Chao Phraya Chakri (Rama I) moved the capital one last time, relocating it on the river's eastern shore within an elaborate fortress.

Secure yet lavish, Rama I's Grand Palace was the first outpost in what would become modern-day Bangkok. So that is where our Krung Thep tour begins.

2. This ornate doorway marks the entrance to a minor Bangkok wat – one of some 400 throughout the city.
3. Thai artistry is expressed in this temple's mural and the musical instrument just in front of it.

The Grand Palace and Environs

Nestling in a voluptuous curve of the Chao Phraya river stands the stronghold at the heart of this modern metropolis. A phantasmagoria of curlicued rooftops, golden spires, and ornately carved statuary, the Grand Palace compound is a 61-acre (218,400-square-meter) assortment of towers, temples and royal residences, all contained within the protective embrace of a 1.2-mile (1.9km) castellated wall.

Rama I (founder of the still-reigning Chakri dynasty) began constructing the palace in 1782. To make room, the Chinese community that inhabited the district was displaced; thousands of Khmer prisoners of war dug canals to link two bends in the Chao Phraya, thereby creating a moat around the royal region.

4. Repeating rooftops tower over a visitor to the Grand Palace.
5. Two painted soldiers guard a Grand Palace doorway.
6. Elevated pavilions overlook a Grand Palace garden.

Rama I modeled the palace itself on the 400-year-old former capital at Ayutthaya. Like its predecessor, the new palace complex included throne halls, royal residences, administrative offices, and temples; the builders even reused materials that had been salvaged from Ayutthaya after its 1767 destruction by the Burmese. Fashioned in the traditional Thai style – incorporating towers, murals, glass mosaics, intricate carvings, and gilded pediments, and roofed with vivid porcelain tiles – the buildings looked out over expansive lawns and gardens, including the Sanam Luang ("Field of Kings") (Later Chakri kings would augment the Grand Palace with architectural elements from other lands: Rama III introduced Chinese-style porcelains and statuary; Rama IV added a miniature replica of the Khmer temple Angkor Wat, now in Cambodia; and Rama V invited British architects to design the Chakri Throne Hall in 1882.)

7. A carved wooden *garuda* (mythical half-man half-bird creature) spreads his wings under the eaves of a Grand Palace building.
8. Within the Grand Palace, a stylized stone lion guards a door.
9. Three monks take the air in one of the Grand Palace courtyards.
10. Flanked by multi-tiered ceremonial umbrellas, a silver shrine stands proudly in Wat Phra Kaeo.
11. Wat Phra Kaeo's ivory-colored towers cluster together, almost seeming to share in prayer.

For almost 150 years, the Grand Palace served as the kingdom's governmental and religious nucleus. The Outer Court housed administrative functions: the Royal Treasury, the palace guards' headquarters, and the defense ministry. The Inner Court was a purely female domain, housing the king's wives, daughters, and concubines – as well as their guards and attendants, all of whom were women. Appropriately, the Central Court was the monarchy's core. It contained not only the ruler's residence but the buildings where he conferred with his officials, received foreign dignitaries, and carried out affairs of state. Nowadays, although the royal family no longer lives at the Grand Palace – having moved up to the Chitralada Villa in 1920 – the king regularly returns to the complex for coronations and diplomatic receptions; the throne halls still house his regalia, including the nine-tiered Great White Umbrella of State and the fulsomely ornamented Great Crown of Victory (itself topped by a minute umbrella).

12. Wat Phra Kaeo is home to many carefully carved and painted towers like this one.
13. The massive columns that surround the Wat Phra Kaeo courtyard dwarf even the beautiful shrines that stand within.
14. The huge *chedis* (reliquary towers) of Wat Phra Kaeo gleam in the moonlight.
15. Delicately inlaid doors adorn the interiors of Wat Phra Kaeo.

16. This ornate *nagack* or demon guard stands to attention outside one of the buildings at Wat Phra Kaeo.
17. View of Wat Phra Kaeo from Chao Phraya.

16

17

The king also returns regularly to perform his duties at the Wat Phra Kaeo (Temple of the Emerald Buddha). This ornate, gold-laden shrine houses the nation's most beloved statue of the Buddha, a 15th-century figure (actually not emerald, but jade) that sits cross-legged as if in meditation: it measures 26 inches (66cm) tall and 19 inches (48cm) across from knee to knee. Three times a year, the king – or a prince appointed by him – ceremonially changes the statue's robes: the Buddha is adorned in a crown and some jewelry for summer, a golden shawl for winter, and a monastic robe and headdress for the rainy season. In Buddha's very shadow, meanwhile, are 178 scenes from the revered Hindu epic, the *Ramayana* (here called the *Ramakien*), vividly painted on the walls of the encircling cloisters.

18. Wat Phra Kaeo's vividly colored tile walls and roofs are bordered by *cho fas* ("tassels of the air" or roof finials) and surmounted by dancing demon figures.
19. Between a pair of Chinese-style floral columns roars a pride of stylized lion statuettes.
20. and 21. Iridescent tiling, flame-bedecked arches, and needle-like golden spires adorn a small tower in Wat Phra Kaeo.

20

21

In fact, Thai kings (though themselves Buddhist) bear the title "Protector of All Religions" – and they themselves are venerated almost to the point of idolatry. Photos of the king and queen hang in almost every house; framed portraits and quotations of the royals festoon shops, offices and factories. The current monarch, King Bhumibol (officially Rama IX), was crowned in 1950 – which makes him the country's longest-ruling king – and he is a conscientious ruler. "[King Bhumibol] is an attractive, high-profile figure, who spends a lot of time helicoptering around the remoter regions of the kingdom, setting up ... irrigation projects, hydro-electric schemes, schoolhouses, medical centers, immunization programs, temple restoration, road construction, etc.," notes author Charles Nicholl in his book *Borderlines.* "He is a cosmopolitan man: he was born in America, grew up in Switzerland, and speaks fluent English and French ... a typical Thai blend of tradition and modernity."

22. On this Wat Phra Kaeo roof, the central *garuda* (mythical half-man half-bird creature) supports the gilded figure of a king, while the surrounding vines also blossom into crowned dignitaries.
23. The Royal Family.
24. Golden *chedis* point skyward inside the Wat Phra Kaeo complex.
25. This golden tower embodies the characteristic Thai fondness for multilayered, multidimensional structures.

Flanking the Grand Palace, as if on spiritual sentry duty, are two historic temples. The one slightly to the north of the palace, along the riverbank, is Wat Mahathat (Temple of the Grand Relic). Much of the original temple building burned down after an 1801 fireworks display, so the wat is noted less for its aesthetics than for its history. Before ascending the throne, the 19th-century King Mongkut (Rama IV) spent the first few years of his 27-year monkhood here. Nowadays, the lively complex encompasses a Buddhist university, a meditation center, and weekend outdoor markets where vendors proffer icons, charms, animals, foodstuffs, herbs, and clothing. Among the wares are small Buddha amulets, meant to help the wearer with problems ranging from snakebite to plane crashes.

26. A gilded *garuda* guardian stands watch, its back against a mosaic wall and its crown surmounted by the head of a king.
27. Within a Wat Phra Kaeo chamber tiled with gold, a stone Buddha sits meditating.

28. An azure-glazed *garuda*, clad in brightly colored and mirrored mosaic tile, grinningly supports a gilded tower in Wat Phra Kaeo.
29. A statue of a mythological creature.
30. Splendid yet serene, this gilded figure smilingly stands near one of Wat Phra Kaeo's ornate towers.

To the south is Wat Pho (short for Wat Photharam, "Monastery of the Bodhi Tree," which was actually the name of a 16th-century temple in this location). First rebuilt by Rama I, Wat Pho is Bangkok's oldest and largest temple. Now, however, it is best known as the Temple of the Reclining Buddha. Inside the central building reposes an enormous figure of the Buddha lying on his side. Molded out of stucco and gilded from head to toe, the figure is 51 yards (46 meters) long. The soles of the feet (commonly considered an ignoble part of the body) are intricately inlaid with mother-of-pearl designs depicting the 108 auspicious characteristics of the Buddha. Hundreds of other Buddha images also reside here, because Rama I set out to amass Buddhas from all over his kingdom in Bangkok. Of the almost 1,250 statues he collected, 689 are now in Wat Pho – as are the king's own ashes, housed inside one of them.

31. With the tail of a peacock and the face of a man, this *garuda* guards the interior of Wat Phra Kaeo.
32. Overlapping tiled rooftops are a common architectural motif in classical Thai architecture.

Wat Pho became the kingdom's first university in the early 19th century, when Rama III encouraged scholars and experts to set up an academy here. Visitors can still read their teachings, inscribed on marble slabs in the courtyard or recorded in paintings, drawings, carvings and statues. At present, however, the primary discipline taught here is the ancient art of Thai massage. The Wat Pho School of Thai Massage, considered the finest in the country, is open to the public; an hour-long massage can be had for 200 baht (about US $5).

34

35

36

33. Reaching toward the heavens, a multicolored *prang* echoes the detailed ornamentation on the walls of Wat Phra Kaeo.
34. and 35. The exploits of mythical heroes and demons are depicted in Wat Phra Kaeo's vividly detailed murals.
36. Tiled roofs, parallel pillars, and flame-like finials decorate the upper reaches of Wat Phra Kaeo.
37. A view of the Reclining Buddha from this angle clearly indicates just how big this enormous statue really is.

Another physical discipline associated with the Grand Palace and local temples is Thai dance-drama. This enduring art takes several forms, the best-known of which are *khon* (a masked enactment of the religious epic called the *Ramakien*), *lakhon nai* (a less formal, more secular style, often performed by women), and a more recent variant, *likay* (a heartier, earthier parody that incorporates double-entendres, puns, and slapstick).

38. A smaller reclining Buddha reposes against a bejeweled pillow.
39. Some of the reclining Buddhas at Wat Pho are almost tiny, such as the silver one resting on this altar.
40. The 51-yard (46.6-meter) long Reclining Buddha wears a blissful smile to signify his entrance into a higher spiritual plane.

41

42

43

41. Scenes of the Buddha revealing his holiness are pictured in mother-of-pearl on the soles of the Reclining Buddha's feet.
42. On the Reclining Buddha's feet are pictured auspicious signs of the Buddha; notice also the ridges embossed in the statue's toes.
43. This seated statue is one of the 689 Buddhas housed at Wat Pho.

Originally developed from Khmer influences, the four-centuries-old *khon* was traditionally performed in the palace for the entertainment of the king and his court. Bejeweled, graceful dancers use slow and stylized movements to dramatize the adventures of heroic brothers Phra Ram and Phra Lak, along with the monkey-god Hanuman, his simian army, and other deities, giants, and beasts. All wear vividly embroidered costumes; some even wear papier-mâché masks decorated with gold, lacquer, and plastic jewels. Centuries ago, *khon* performances lasted an entire day – in fact, a performance of the entire *Ramakien,* with its 311 characters, would take more than 720 hours – but contemporary versions of various episodes may be as brief as three hours. The gentler, more fluid *lakhon* form, once performed exclusively by court ladies in the Grand Palace, depicts stories drawn from classic Thai legends; most actors do not wear masks, but do wear the spire-shaped golden headdresses and bespangled clothing seen in the *khon.* Both types of dance-drama are accompanied by traditional instruments – usually five percussion pieces and one woodwind – playing tunes that indicate the emotions onstage.

44. and 45. Bell-shaped, mosaic-clad *chedis* (reliquary towers) line the perimeter of Wat Pho's shady courtyard.
46. Small stone statues pop up throughout the colorful Wat Pho complex.
47. In the Wat Pho courtyard, a clan of stone figurines is posed in postures characteristic of healing massage.
48. Chubby carved attendants crouch beneath the weight of a multilayered stone obelisk at Wat Pho.

The common people, excluded from these palatial proceedings, developed their own version, *likay*, a burlesque of *lakhon*. Generally performed during temple festivals, *likay* is played for laughs, reveling in puns, jokes, and slapstick as it presents melodramatic tales of lost love. The actors wear gaudy, overwrought outfits that ape those of the *likhon*, liberally covering their faces with makeup. Meanwhile, tourists interested in Thai dance are most likely to see it at various shrines around the city, such as the Erawan Shrine (see Chapter 8) or the Lak Muang (City Pillar). Anyone may hire *likhon* or *likay* dancers to perform near these shrines to demonstrate their gratitude for wishes granted.

49. A Thai dancer
50. A dance scene

The Wats of Central Bangkok

52

Magnificent as they are, the three wats we have just explored in and around the Grand Palace constitute only a tiny fraction of Bangkok's 400 or so temples. (One reason for Bangkok's abundance of temples and monasteries is the Thai custom of *sangha,* or monkhood: traditionally, every male – including kings and princes – enters the monastic life at least once, preferably for three months or more.) Near the Grand Palace stand Wat Rajabophit and Wat Rajapradit, facing each other across a canal or *khlong.* Wat Rajapradit, on the khlong's west bank, was built first, by the order of King Mongkut (Rama IV). The temple combines rows of gilded carvings and a smattering of *prangs* (towers) with buildings faced in European-style gray marble. This mix of East and West is intensified in the neighboring temple, Wat Rajabophit, which was commissioned by King Chulalongkorn (Rama V) and constructed during the 1870s and 1880s. The circular enclosure is clad in made-to-order Chinese porcelain tiles, while the doors are guarded by relief carvings of soldiers in European uniforms. Outdoors, the main attraction is the 140-foot (43m) tall Sri Lankan-style golden spire; the interior, however, is decorated in an elegant Italian Renaissance mode.

A few blocks to the north-east stands Wat Suthat, a temple begun by Rama I in 1807 and not completed until the reign of Rama III. This wat is composed of elements from the seven holiest Buddhist sites, including Wat Chet Yot in the northern Thailand city of Chiang Mai. In the central shrine, exquisite murals (restored in the 1980s) intricately depict Buddhist cosmology; at the entrances, 18-foot (5.5m) doors carved out of teak stand tall. (One such carving, by Rama II himself, now resides in the National Museum.) One hundred and fifty-six golden Buddhas fill the cloisters around the shrine's periphery.

53

Even this opulence can seem small, however, when compared with the adjacent Sao Ching Cha (Giant Swing), a relic from a daring (and now discontinued) Shaivite ritual. The swing's frame towers several stories high, with its two teak posts painted red and surmounted by an elaborate crosspiece. A swing with a wooden seat once hung there, for use in a midwinter harvest rite in which groups of two to four young men would stand together on the seat, swinging it as high as 82 feet (25m) in the air. During the arc, the leader would then try to grab in his teeth one of three gold-filled bags hanging high atop a nearby pole. Picturesque and exhilarating, the ritual was also very dangerous. So many participants and onlookers died that King Prajadhipok (Rama VIII) abolished the practice in the 1930s.

51. Dainty statues of elephants flank this Wat Rajabophit altar.
52. Detailed yet monochromatic stone statuary stands in the courtyard at Wat Suthat.
53. The exterior of Wat Rajabophit is adorned in Thai style – but the interior decor is Italian Renaissance.

Due north of Wat Suthat is Wat Bovornivet, also known as Wat Bowon. This serene, semi-secluded temple has been intimately connected with the Chakri kings since its founding by King Mongkut (later Rama IV). He spent several years as its abbot during his 27-year pre-monarchy monkhood. Since then, a number of kings have undertaken their own monastic duties here; the current monarch and crown prince, King Bhumibol and Prince Vajiralongkorn, both received their ordinations here. The wat also serves as the national headquarters of the Thammayut sect Mongkut established some 150 years ago.

Wat Rajannada, to the south-east, was built by Rama III in the mid-19th century to honor his granddaughter. Although architecturally derived from the design of a 2,000-year-old Sri Lankan temple, the central monastery is made entirely of steel, a surface which lends the structure a pallid, ghostly gleam when seen by moonlight.

Further south-east, one encounters Wat Saket and the neighboring Golden Mount. The temple itself was built by Rama I in the 18th century, but the Golden Mount, which stands on the western edge of the wat's grounds, was a trickier and more time-consuming construction project. Rama III set out to artificially replicate the Golden Mount in Ayutthaya, the former capital. But when erected on Bangkok's spongy, soft delta soil, the *faux* mountain collapsed. Not until the reign of King Chulalongkorn (Rama V), who consolidated the foundation by sinking 1,000 teak logs into the ground, could the structure be completed. The 250-foot (76-meter) central gilded tower is said to house relics of the Buddha himself; it is reached via 320-step circular stairways. These days, the Golden Mount is one of Bangkok residents' favorite promenades, thanks to its panoramic vistas.

54. In Wat Saket.
55. 156 golden Buddhas line up along the walls of the Wat Suthat cloister.

Thon Buri and its Waterways

56. Extending over the waters of Bangkok's *khlongs*, some houses appear almost to be docks.
57. Commerce on the Chao Phraya: This paddling peddler sells fruit to some waterborne passers-by.

By crossing to the Chao Phraya's western shore, the visitor can travel back to Bangkok's historical and cultural genesis. The district of Thon Buri served as Rama I's capital from 1767 to 1782, before the construction of the Grand Palace. Ever since, the river and the web of canals springing from it have defined Bangkok's character.

Today, longboats, barges, and ferries busily crisscross the Chao Phraya, delivering passengers, cargo, and foodstuffs along what writer Thurston Clarke has called "the city's widest and most convenient highway." But anyone who visits Thon Buri can see that the river is far more important than that. For centuries, so many streams and canals (*khlongs*) wound and intertwined through Bangkok that the life of its people shimmered on the surface of the water. Residents built their houses on rafts or stilts; farmers and merchants purveyed their goods from gaggles of sampans clustered into floating markets. Europeans used even to describe the city as "the Venice of the East." And although this appellation no longer applies – by the mid-20th century, many *khlongs* had been filled in and transformed into automobile-ready roads – that atmosphere lives on in Thon Buri. Rustic villages – stores, bars, barbershops – and traditional mangrove-wood stilt houses still line the canals, connected, at times, by wooden boardwalks. The people bathe, wash their laundry, and swim in the murky water. They even conduct their commerce there: Thon Buri is full of latter-day merchants peddling everything from cooking utensils to coffee. (The peddlers, however, are not paddlers: One way in which Thon Buri's way of life has kept pace with modern life is in its reliance on motorboats.)

58. A *khlong* fruiterer delivers her wares by boat.
59. Another small floating market congregates in this *khlong*.

60

61

60. Some *khlong* dwellers find additional room by adding stories onto their stilt houses.
61. Some guesthouses that border the water, like this one, offer tourists an exotic *khlong* experience.
62. Not all *khlong* houses are humble; notice the statuary and garden in front of this one.
63. Buildings near the *khlongs* can sometimes be vulnerable to flooding if the banks are not reinforced.

Even the king himself takes to the water from time to time. Thai monarchs traditionally embark in ornate vessels with magnificent figureheads, which have been recreated at the Royal Barges Museum, on the Khlong Bangkok Noi, just off the Chao Phraya. This fleet of fantastic barges – carved, gilded, and vividly painted in red, gold, and black – numbers more than 50. The biggest is about 160 feet (50 meters) long. The king's barge, first launched in 1914, is named *Si Suphannahongsa* in honor of its figurehead, which depicts a *hong* (the sacred goose on which Brahma rides). The 165-foot (50m) solid teak boat weighs more than 15 tons, and requires a crew of 64, including parasol-bearers, rowers, rhythm-keepers and a chanter. Although several of the barges have cannons mounted in their bows, the royal boats are most commonly used for civic or religious ceremonies, such as the presentation of special robes to the monks at west-bank wats.

64. Porches extending over the water give *khlong* dwellers a place to enjoy the fresh air and the view.
65. A motorized longtail boat whirs down a Bangkok waterway.
66. Some canals are much narrower than others; this one has the added advantage of a walkway along its bank.
67. Gaily colored longboats stand ready to transport tourists and workers up and down the Chao Phraya.

The most famous of those Thon Buri temples is Wat Arun (Temple of Dawn), named after the Indian dawn goddess Aruna. On the bank of the Chao Phraya, just across from Wat Pho, Wat Arun aims its intricate 220-foot (67-meter) *prang* at the sky. Just 49 feet (15m) high in 1780, when general-turned-king Taksin brought the Emerald Buddha here for a temporary stay, the *prang* was extended to its present height by Rama I and Rama II. Rama IV elaborated further by having it adorned with thousands of colorful pottery fragments. Lined with row upon row of carved demons, the central *prang* also features a set of very steep external stairs, symbolizing the difficulty of climbing to a higher existential plane. The tri-level tower structure represents the sacred Mount Meru; on top, there sits an image of the god Indra on his three-headed elephant steed. Four smaller *prangs* at the wat's corners echo the design with figurines of the wind god Nayu on horseback.

68. This red *garuda* guards a gun boat from the reign of Rama I.
69. This *garuda* figure strikes a traditional pose, with the *naga* serpent in his arms.
70. A white *garuda* roars protectively at the head of a royal barge.
71. Arms akimbo, this blue *garuda* figurehead grimaces at visitors to the Royal Barges Museum.

72. and 73. This *naga* (protective many-headed serpent) figurehead keeps many-eyed watch over one of the royal barges.
74. An assortment of fearsome guardians adorns the collection of royal barges.

Slightly south of Wat Arun, Wat Kalayanimit stands on the river's edge. Dating back to the reign of Rama III, this wat houses a colossal gilded Buddha image. Outdoors, the courtyard is studded with Chinese statuary that was once used as ballast for empty rice barges; its whitewashed tower contains the largest bronze bell in Thailand. A few steps further south, Wat Prayoon is known for the artificial hill near its entrance: At the request of Rama III, it was built in the shape of a melted candle. In the courtyard, a small pond teems with turtles released by the faithful as they seek to earn spiritual merit.

75. At the center of the king's barge is this multilevel platform, supported by dozens of small golden figurines.
76. Detail of a barge.
77. The central platform of this royal barge is delicately detailed and intricately gilded.
78. This view of Wat Arun, from across the Chao Phraya, is also depicted on Thai banknotes.

To the north, not far from the royal barges, is Wat Suwannaram. Originally the site of an Ayutthaya-era temple, this spot became a royal monastery during Rama I's reign; renovated by Rama III, it was finally finished in 1831. The detailed yet elegant murals inside – which depict, among other things, the Buddha's last ten lives on earth – are considered among Bangkok's finest surviving works of the period.

As this host of waterside temples might suggest, Thais are deeply aware of the importance of their rivers and canals. They even incorporate water into a number of religious observances. Every April, during the three-day lunar New Year celebration called Songkran, Thais gleefully douse one another. "Fire hoses, garden hoses, in fact every hose in the country was turned on, Thai on Thai," reported photographer Joel Simon, who got caught in the deluge. "Water from buckets, cups, cans, and leaky vessels was being hurled

79

80

81

82

83

79. A Wat Arun courtyard is graced by gray marble pillars and a bell tower.
80. An enormous *garuda* (mythical half-man half-bird creature) towers over visitors to Wat Arun.
81. Opulent ceilings grace the inside of sky-scraping Wat Arun.
82. Red and gold paint sets off the figures of these seated Buddhas lining a hallway at Wat Arun.
83. A venerable monk descends from a Wat Arun temple.

off fourth-floor balconies, the backs of pickup trucks, ox carts, and from every window facing the street." In fact, it's considered an honor to be drenched, since the custom derives from an old tradition of sprinkling water on Buddha images. Also, during November's Loi Krathong festival Thais give thanks to the Goddess of the Waters by launching banana-leaf boats freighted with flowers, candles, and incense into their lakes and waterways.

84. Floating market.
85. In this cramped *khlong* community, neighbors gain some privacy via striped awnings – and laundry that's been hung out to dry.
86. Built on stilts pounded into the soft earth, these *khlong* (canal) houses seem to sit right on top of the water.
87. With durian fruits and other produce for sale, these paddling peddlers make their way down a Bangkok *khlong.*
88. Things are going swimmingly as father and child cool off in a khlong (canal).

89

90

But for all the spirituality, beauty, and ease that the surrounding water lends this sensual city, it also constitutes a threat. Flooding has become increasingly frequent owing to Bangkok's recent building boom. Burgeoning construction has filled in swampland and closed up the old canals, leaving little room for natural drainage. Spillover from dams and hydroelectric plants further north add to the outpouring. A 1995 flood immersed some parts of Bangkok in more than 6 feet (2 meters) of water, causing an estimated $1 billion-worth of damage. Worst of all, like Venice, Bangkok is watching its water consume it. The delta land underlying the city – some of it below sea level – is weakening and eroding, especially in the metropolis' eastern sections. To stem the tide (literally), ambitious engineers have proposed adding parkland, embankments and channels.

89. Thais who live near the *khlongs* (canals) buy many of their supplies from floating peddlers.
90. *Khlong* life may appear rustic – but thanks to the maritime merchants, thirsty Thais can get even such modern-day staples as Pepsi.
91. Food, flowers, and much more is sold by the vendors at Bangkok's floating markets.

The Dusit

The Dusit section, in north-central Bangkok, is a metropolitan monument to the international tastes of Thailand's beloved King Chulalongkorn (Rama V). During his 32-year reign (1868–1910), Rama V himself oversaw the neighborhood's development, calling for European-style, tree-lined boulevards arranged in a grid and incorporating many Western architectural details into its buildings. Ironically, this district, so redolent of the *farang* (foreigner), now houses many official centers of Thai government.

One striking example is the Ananta Samakorn Throne Hall. Originally the site of Chulalongkorn's throne, and then, until 1974, the home of the National Assembly, this neo-Classical domed white marble building was designed by a team of Italian architects in 1907. The same architects also built Ban Phitsanulok (the Prime Minister's House), using a Venetian Gothic style that includes flower-shaped mullioned windows. The district's other throne hall, the Abhisek Dusit Throne Hall, contains such Western touches as Victorian-style gingerbread moldings, Moorish-looking geometric trim, and checkerboard tiling. Completed in 1904, this building now houses a museum of native Thai crafts, under the auspices of the present Queen Sirikit.

Wat Benchamabophit is nicknamed the Marble Temple, because it blends European aesthetics (gray Carrara marble walls and minimalist columns) with typically ornate Thai details (gilded, elaborate roof, flame-like spires). Stained-glass windows depict scenes from Thai mythology. Designed for the king by his brother Prince Naris, in collaboration with Italian architect Hercules Manfredi, and finished in 1911, the wat now contains the ashes of Rama V himself, entombed in the base of the central statue of the Buddha. In the courtyard, an assortment of 53 Buddhas embody artistic styles from all over the world.

Even the geometric Vimanmek Palace, the largest golden-teakwood building in the world, has some Victorian touches. Elaborate fretwork adorns the eaves, and mullioned glass fills the windows. Built in 1868, the 81-room mansion was Rama V's residence for six years in the early 1900s. Interestingly, aside from the floors, the house was constructed entirely without nails. It was moved to its current location in 1910, closed in 1935, and restored and reopened in time for the capital's 1982 bicentennial. Another notable distinction is that the Vimanmek Palace was the first building in Thailand to boast electricity and indoor plumbing.

92. Wat Benchamabophit

Abutting the palace grounds is the Dusit Zoo, which started out as Rama V's botanical garden. Within its pastoral 47 acres (19 hectares) reside some 200 reptiles, 300 mammals, and 800 birds, including such rare species as bantengs, gaurs, serows, rhinoceroses, white-handed gibbons, and Komodo dragons. Nevertheless, the most significant animal of this area would have to be the white elephant. These pale pachyderms, believed to be auspicious, are collected by Thai kings (and were formerly depicted on the Siamese flag). The great beasts are honored at the Royal Elephant Museum, on the grounds of the Vimanmek Palace in a pair of onetime elephant stables. Bones, photos, a lifesize statue, and other artifacts emphasize the species' traditional importance. Meanwhile, on the verdant grounds of neighboring Chitralada Royal Palace (King Bhumibol's Bangkok residence, which is hidden from the public), eleven royal white elephants are currently housed and trained.

Perhaps because Rama V's spirit so palpably pervades the Dusit, a new movement venerating the monarch is centered here – specifically, around a bronze statue of the king near the Ananta Samakorn Throne Hall. Beginning in 1991, Chulalongkorn's admirers have turned this statue into a quasi-religious shrine, dropping off flowers, candles, and bottles of whisky there. This nostalgic movement, some observers believe, stems from the economic woes of the 1990s and a resulting mistrust of modern politics. Ironically, although Rama V is remembered as the king who fended off Western colonialism, he also contributed hugely to his country's Westernization. Architectural evidence of this is all around.

93. The Ananta Samakorn Throne Hall
94. An orchid.
95. Exotic birds in Dusit Zoo.

96

97

A Mosaic of Ethnicities

Just as some of the finest examples of Bangkok's architecture contain international flourishes, so too does the city's population take on added panache from its cultural minorities – even though they constitute only a small percentage of the people: less than 3 percent of Bangkok's population is non-Thai.

By far the largest minority are the Chinese, who first arrived in the 14th century and have been immigrating steadily since the 18th. Chinatown is the city's most congested neighborhood, with a population density of about 390,000 persons per square mile (150,000 per square kilometer). This lively district (often referred to as Sam Peng) was once home to opium dens, gambling halls, and brothels. Nowadays, however, almost all the commerce is on the up-and-up, although one market's moniker is a reminder of the district's past: Nakhon Kasem ("Thieves' Market") was so dubbed for its alleged trade in pilfered goods. Latter-day shoppers can find Chinese and Thai antiques, metalware, and musical instruments here. In fact, Chinatown in general offers some of the city's lowest prices on merchandise ranging from jewelry and hardware to preserved snake parts (used in Chinese medicine). Merchants often live above their stores in the area's characteristic shophouses. Meanwhile, on the waterfront, the enormous and colorful Pak Khlong market, overflowing with fruits and vegetables, is also the city's largest wholesale flower bazaar.

The area's most notable temples are Wat Neng Noi Yi and Wat Traimit. The former, clad in red and green ceramic glaze and topped by fierce Chinese dragons, mixes elements of Confucianism and Taoism with its slew of gilded Buddha images. The latter – its name means "Temple of the Golden Buddha" – boasts the world's largest solid gold Buddha, 13 feet (4 meters) high and weighing five and a half tons. Originally covered in stucco to protect it from looters, the Sukhothai-style icon's inner self finally emerged in 1957, when movers accidentally cracked the exterior and caught sight of the gold.

Just to the west of Chinatown is Pahurat, Bangkok's Indian quarter. Renowned for its fine fabrics, especially the Thai silk, the Pahurat Market also features sandals and traditional ornate Indian jewelry. The air is full of the spicy allure of Indian food, thanks to dozens of nearby food vendors. Another neighborhood favored by Indians is the Bangrak district, which displays a particularly Bangkok-style example of ethnic cross-pollination: A Bangrak temple, the 130-year-old Sri Mariamman, exhibits vividly painted Hindu deities on its facade, while inside, it houses a host of gilded Shivas, Vishnus, other Hindu deities, and Buddhas. Visitors of any faith are free to enter and pray.

96. This head of Buddha, though gargantuan, is nevertheless covered by an even larger ceremonial umbrella.
97. A golden Buddha presides over the offerings of the faithful.

Thai Life

Bangkok's landscape and architecture are among the most picturesque in the world – but even they do not capture the city's innermost essence. The capital's true animating force is its sensuousness – not just in the carnal carnival of the Patpong red-light district but in the spicy savor of its food, the brilliant hues of its flowers and fabrics, and the warm breezes of its days and nights. This celebration of the senses infuses the Thai people's endless quest for *sanuk,* the joyful relishing of life's pleasures – *sanuk* is a sensation that may arise from attending festivals, getting together with friends, gambling, or maybe just taking a walk around the neighborhood.

98. Three dancers demonstrate the typical costume and gestures of traditional Thai dance.
99. Although outdoors, these women are assembling a typically Thai dinner using broth, spices, and vegetables.
100. In the wealthier sections of Bangkok, residents even get satellite TV reception.

Westerners' preoccupation with time and the future, however, can be a threat to *sanuk,* as can disagreement and discord. For that reason Thais – some 90 percent of whom espouse Buddhism and its continual life cycles – try to avoid conflict and maintain their equanimity. "A 'cool heart' is the ideal of a Buddhist," academic Carol Hollinger wrote in the 1950s. "It does not mean lack of compassion. It stresses the need to keep your heart free of entangling and destructive emotions of both joy and sorrow that assault you from the material world." The natural results of cool-heartedness are flexibility and acceptance, which infuse the entire society. "Buddhism fits Thai ways well," noted one Thai writer. "Because we believe that material surroundings are an illusion, and only the internal world is real, to be Thai is the ability to be anything we want."

101. Holding an incense stick and the traditional white flower, a Thai gentleman kneels at prayer.
102. A Thai lady "earns merit" by lighting candles at a religious shrine.
103. Shoppers stroll through one of Bangkok's many street markets.

It is that Buddhist mind-over-matter self-possession which combines with *sanuk* – the sensual savoring of what life has to offer – in what may be Bangkok's most notorious locale: downtown's Patpong district. In these few blocks of bars and cabarets, scantily-clad prostitutes and exotic dancers – each night paid far more than the average Thai worker earns in a week – cavort and flirt with their male visitors, offering what writer Pico Iyer has called "love in a duty-free zone." Yet he and others note that the women who work here are not defined by their work: any young girl dancing naked at midnight may well be engaging in religious rituals at noon. "The apparent ease with which Thais appear able to adopt different forms, to swim in and out of seemingly contradictory worlds, is not proof of a lack of cultural identity, nor is the kitsch of Patpong proof of Thai corruption," asserts travel writer Ian Buruma. "Under the evanescent surface, Thais remain in control of themselves."

105. A restorer regilds a dilapidated mural.

104. Ancient and modern merchants do business side by side.

106. An elephant amidst the traffic.

107. This elderly lady takes a moment to rest and read by the roadside.
108. Soccer is another source of *sanuk* for Thai children.

Bangkok's other pleasures of the flesh, meanwhile, are much less morally complicated. Thai food, for example, is delightful in its inventive freshness. Heavily reliant on rice and fish, Thai food gains its immense variety from a host of additional ingredients, ranging from the sweetness of coconut milk to the bite of chili peppers (brought to Thailand by Portuguese missionaries in the 17th century). Such is the appeal of Thai cooking that Bangkok's finest hotel, the Oriental Hotel, now offers a week-long cooking school to interested visitors.

Naturally, markets in every neighborhood overflow with abundant, tempting foodstuffs – fruit, vegetables, spices, fish, meat, poultry – plus items that stimulate all the other senses: fresh-cut flowers, polished metalware, vivid fabrics, and pets (dogs, cats, squirrels, goldfish, monkeys). The most famous

109. Colorful and delicious, Thai meals often center on seafood.
110. Little girls dress up for a New Year's party.
111. Markets like this one can be found in every Bangkok neighborhood.

of these sensory cornucopias is the weekend flea-market in Chatuchak Park, located north-east of Dusit. More than 5,000 merchants crowd into an area of almost 30 acres (12 hectares), proffering food – of course – as well as bonsai, fighting cocks, clothes, antiques, native craftwork, plants, paintings, ceramics, books, and Buddhas. Elsewhere, at the Thewet flower market, spanning a canal in the heart of the Dusit, blooms and buds in every conceivable color and shape abound amid rows of seedling trees and stacks of ornamental pots. To the south, the Sanam Luang parade-ground abutting the Grand Palace is ringed by peddlers of amulets, lotions, and other trinkets, while downtown's Pratunam Market, wedged into sidewalks and narrow lanes near Siam Square, offers strollers good deals in clothing, jewelry and leather goods.

Beyond shopping, Bangkok's people seek *sanuk* in any number of other ways. Favorites include gambling, comic operas, and Thai versions of what Westerners would call boxing, volleyball, and kite-flying. Thai boxing (*muay thai*), which dates back to the 15th century, is the country's most popular sport. The men in the ring use their gloved hands to punch – and their feet, elbows and knees to kick, jab, and push. Not surprisingly, Thai boxing also incorporates beauty. Before each bout, the boxers strut and dance as a ringside orchestra of drums, cymbals, and the Thai oboe plays ceremonial music. Takraw, commonly played in public parks, looks like a combination of volleyball and soccer. Players kick or head a ball over an elevated net to win points. American sportswriter E. M. Swift wrote of one game he witnessed, "Every player could spike the ball with his feet, sometimes doing a full flip afterward to land upright. The best players were so skilled they could take a spike with a foot, and then bunt the ball over with their heads." Meanwhile, during the windy season (February to April), the Sanam Luang is the scene for Thai-style "kite-fighting," in which large "male" kites with bamboo talons try to catch smaller "female" kites, which are simultaneously flitting about trying to lasso the males with kite string.

In the end, of course, *sanuk* is where you find it – and you can find it in every corner of this pleasure-loving city.

112. The selling of cult objects.
113. As evening falls, dinner preparations begin.
114. This elderly gentleman is blind, but still enjoys making music with his flute.

Modern Bangkok

Even as many of Bangkok's most famous buildings hark back to earlier Thai capitals and culture, much of what propels Thailand into the 21st century pushes onward and upward in the downtown business district. There, in the city's south-eastern section, giant high-rise buildings loom in the smog: the metallic Bank of Asia headquarters, the Baiyoke Towers side-by-side like fraternal twins, the three-legged Elephant Building ...

This is the area where Bangkok has always found an interface with the rest of the world. In the 19th century it was the city's original port and foreign trade district. The Portuguese built the city's first embassy in 1820 (together with an adjoining commercial center). The subsequent influx of Europeans led natives to name the neighborhood the Old Farang quarter (a *farang* is a foreigner from Europe or North America). To this day, Western and Japanese residents still congregate in this affluent neighborhood.

Among the area's landmarks are the Cathedral of the Assumption and the Oriental Hotel. Built in 1910, the rose-windowed cathedral is decorated in rococo style and contains a French marble altar. It faces the city's only European-style square. Around the square's perimeter are Assumption College, a Roman Catholic mission, and a Roman Catholic center. Down by the riverside stands the Oriental Hotel, still considered one of the world's finest. Established in 1876, rebuilt in 1887, and augmented in 1958 and 1976, the Oriental was Thailand's first large hotel. Despite its name and such Asian touches as the enormous, intricately-carved wooden bells hanging from the lobby ceiling, the Oriental is remarkably Westernized. Its original white-shuttered wing contains a clutch of "authors' suites," named after such famous literary *farangs* as Somerset Maugham, Noël Coward, Gore Vidal, Graham Greene, Joseph Conrad, and Barbara Cartland. The Authors' Lounge serves classic English-style high tea.

Notwithstanding the eminence of these august authors, the most important *farang* in Bangkok's history was an American named Jim Thompson. An architect who served in the Office of Strategic Services during World War II, Thompson settled in Thailand after the war as a silk merchant and revived the country's faltering silk industry. A devotee of Thai culture, Thompson purchased six traditional teak houses from Ayutthaya in 1959 and had them brought to Bangkok and reassembled on the bank of Khlong Seen Saen. An aficionado of native arts and culture, he filled the resulting structure with sculptures (including wooden Burmese spirit figurines and a 6th-century limestone Buddha torso), pictures (such as paintings of the jataka), and ceramics, along with personal artifacts from Thailand, Burma, Cambodia, and China. (Another factor in Thompson's fame is the enduring mystery of his

1967 disappearance, which occurred while he was out walking alone in Malaysia's Cameron Highlands. Explanatory theories include a heart attack, an ambush by business rivals, and even an assassination by the CIA.)

At the nearby Erawan Shrine, modern *mores* share space with native traditions. On the site of the old Erawan Hotel (now supplanted by the Grand Hyatt Erawan Hotel), trees were felled in 1956 to clear space for the building. During the construction that followed, mishaps and accidents so plagued the crew that workers finally built a spirit house to placate any displaced deities. (And it is a fact that once the shrine was erected, the accidents stopped.) On the bustling corner where the shrine – now dedicated to the Hindu god Brahma and his elephant vehicle Erawan – stands, incense perfumes the city air. As buses pass the site, passengers inside make gestures of respect in the shrine's direction. Meanwhile, worshippers may emphasize their requests by hiring Thai dancers and musicians to perform. Similarly, the Hilton International, a few blocks away, looms over another holy spot: Saan Jao Mae Thap Thim, or the lingam shrine. Originally a spirit house for a local female deity, this enclave became renowned as a fertility shrine when a worshipper conceived a child shortly after making an offering here. It is now dotted with carved stone and wooden lingams (phallus fetishes) and visited by a steady stream of the faithful.

Down the road from the Hilton, Lumphini Park spreads out over several green and airy acres. Named after the Buddha's birthplace in Nepal, Bangkok's largest park offers two duck-friendly lakes for boating, equipment for weight-lifting, and plenty of room for kite-flying, jogging, playing takraw and practicing tai chi chuan. After exercising, some of the park's regulars seek to boost their health with beverages containing blood or bile from cobras and vipers killed on the spot. A slightly more scientific use of snake derivatives takes place just up the road, at the Thai Red Cross research institute (now known as the Queen Saowapha Snake Farm), where venomous reptiles – again mainly cobras and vipers – have their poison "milked" daily for use in snakebite antidotes.

Happily, some non-reptilian wildlife also dwells in and around the city. Along Silom Road, a major downtown shopping strip, thousands of barn swallows nest from October to March, undeterred by the frenetic traffic. Meanwhile, just north of Bangkok, the grounds of Wat Phailom, an old wooden riverbank temple, serve from December to June as a nesting site for enormous flocks of white-billed storks. Building with leaves stripped from the nearby trees and feeding on snails from nearby rice paddies, the birds now enjoy government protection.

Indeed, despite the rapidity of Bangkok's growth and the modernity of its atmosphere, the Thais are working to preserve their heritage, both natural and national. The Suan Pakkard (Cabbage Patch) Palace, for example, was

assembled in the 1950s from five traditional Thai houses. The palace's Lacquer Pavilion, pieced together from two Ayutthaya-style pavilions, features murals of Buddha's life and the *Ramakien*. Also here are the Ayutthaya period's only surviving paintings of day-to-day life, from the marketplace to the battlefield. For a three-dimensional recreation of 18th-century life, there is Ban Kamthieng, an antiquated dwelling that originally stood in Chiang Mai. Thanks to the preservationist Siam Society, it has been reconstructed in Bangkok and filled with traditional implements: pottery, lamps, even a rickshaw-type cart.

But as Bangkok looks further ahead into the 21st century, it faces the typical urban challenges. Poverty and overcrowding is rampant. Roughly a million people live in the city's slums, and it is predicted that the next decade will swell the city's population by 4 million. Pollution is problematic. The capital's 7 million residents dump thousands of tons of raw sewage into the Chao Phraya river every day. Traffic congestion is inescapable. Because Bangkok is home to 90 percent of Thailand's motor vehicles, the pace is killingly slow. In 1989 the average speed of vehicles on the city's main streets was less than 6 miles per hour (10 km per hour). And always there is the encroaching water. Nevertheless, amid the strain, the residents of Bangkok – the magical, maddening metropolis – will continue to call upon spiritual strength and sensual pleasure to help them in their never-ending quest for *sanuk*.

115. Barges and boats journey down the Chao Phraya in the shadow of Bangkok's modern high-rise buildings.
116. Boat in the AM Chayo Phraya river a seann
117. A smudged sunrise illuminates the Bangkok skyline

Publishing Director: Jean-Paul Manzo

Text: Caren Weiner-Campbell

Design and layout: Newton Harris Design Partnership

Cover and jacket : Cédric Pontes

Publishing assistant: Aurélia Hardy

Photograph credits: Klaus H. Carl

The Thai Tourist Office: 23, 50, 92, 93, 95

Parkstone Press Ltd
Printed and bound in Singapore
ISBN 1 85995 740 4

© Parkstone Press, London, England, 2000

All rights reserved. No part of this publication may be reproduced or adapted without the permission of the copyright holder, throughout the world.